Name:

Address:

Phone:

E-mail:

IF FOUND
RETURN TO

SIDE WALKS

a journal for exploring your city

created & illustrated by
Kate Pocrass

CHRONICLE BOOKS

SAN FRANCISCO

ISBN: 978-1-4521-0657-1

Manufactured in China

Designed by Kate Pocrass

10 9 8 7 6 5 4 3 2 1

Chronicle Books LLC
680 Second Street
San Francisco, CA 94107
www.chroniclebooks.com

CONTENTS
what's in store...

CREDO

& thoughts on exploring your city

JUNE 1 to 30 ALL-INCL.

2037

Although we get wanderlust and dream of faraway lands, our own city always presents us with wonders in the smallest, unexpected details. At times our environment seems old hat, and we forget to stop and stare at the reasons we decided to roost here in the first place. Whether I am running an errand or out with friends, the brightest moments are ones of new discovery in a place that I thought I knew overly well.

This journal will act as your field guide for backyard excursions. As you thumb through, you'll find suggestions for local exploration and the recording of easily overlooked, everyday details. You don't have to travel to exotic, far-flung lands to be inspired. Your front door is your starting place.

The following pages offer space to prep, document while en route, and keep track of important details to share with others. Pages for lists will prompt you to record certain aspects of your surroundings because the particulars of your city too often go unrecorded. Carry this journal with you wherever you wander and create a personal manual to the city you call home.

I encourage you to stray from your predictable path, wander aimlessly, and take note of the peripheries. Keep your gaze wide and your expectations open to see things in a whole new light.

—Kate Pocrass

PREP WORK
checklists, itineraries
& city bearings

GETTING YOUR BEARINGS

Best Way To
Get Around My City: ..

Train: ..
Bus Line: ..
Subway: ..
Ferry: ..
Taxi #: ..

Home Base: ..
Address: ..
Phone #: ..
Cross Streets: ..
Subway/Bus Stop: ..

Best Grocery Store: ..
Favorite Nearby Café: ..
Local Place I Rely On: ..
Nearest ATM: ..
Usual Letter Carrier: ..

Neighbor to the North: ..
Neighbor to the South: ..
Neighbor to the East: ..
Neighbor to the West: ..

LIST THE QUINTESSENTIAL MOMENTS THAT
MAKE UP YOUR FAVORITE DAY IN YOUR CITY

☐ ...

☐ ...

☐ ...

☐ ...

☐ ...

☐ ...

☐ ...

☐ ...

☐ ...

☐ ...

☐ ...

☐ ...

☐ ...

☐ ...

☐ ...

☐ ...

☐ ...

☐ ...

☐ ...

☐ ...

PACKING CHECKLIST

COMFORTABLE SHOES

SENSE OF WONDER

WILLINGNESS TO FIND
SATISFACTION IN
SMALL PLEASURES

OPEN MIND

SPONTANEITY
(ALWAYS HAVE A
COIN TO FLIP)

FAVORITE
PEN

READINESS TO
CLOSLY OBSERVE
THE ORDINARY

SOURCE OF
HYDRATION

ROUTES

FROM WHICH TO DEVIATE

Today's Weather:

Date:

Place To Explore:

Things To See & Do:

☐ ..

☐ ..

☐ ..

☐ ..

☐ ..

☐ ..

☐ ..

☐ ..

☐ ..

☐ ..

☐ ..

..

..

..

..

..

..

..

Today's Weather:

Date:

Place To Explore:

Things To See & Do:

- [] ..
- [] ..
- [] ..
- [] ..
- [] ..
- [] ..
- [] ..
- [] ..
- [] ..
- [] ..
- [] ..

..
..
..
..
..
..
..

Today's Weather: ☀ 🌤 ☁ 🌧

Date:

Place To Explore:

Things To See & Do:

- [] ..
- [] ..
- [] ..
- [] ..
- [] ..
- [] ..
- [] ..
- [] ..
- [] ..
- [] ..
- [] ..

..

..

..

..

..

..

..

..

Today's Weather: ☀ ⛅ ☁ 🌧

Date:

Place To Explore:

Things To See & Do:

☐ ...
☐ ...
☐ ...
☐ ...
☐ ...
☐ ...
☐ ...
☐ ...
☐ ...
☐ ...
☐ ...

...
...
...
...
...
...
...

Today's Weather: ☀ ⛅ ☁ 🌧

Date:

Place To Explore:

Things To See & Do:

- ☐ ..
- ☐ ..
- ☐ ..
- ☐ ..
- ☐ ..
- ☐ ..
- ☐ ..
- ☐ ..
- ☐ ..
- ☐ ..
- ☐ ..

..
..
..
..
..
..
..
..

EXPLORE

get going, navigate & meander

VARIED WAYS OF WALKING

LINGER
(be sluggish and
walk as slowly as possible)

LOOK UP
(stare at all that
you pass by)

LONG STRIDES
(take unusually long steps)

LOOK DOWN
(be sure to inspect
all that is under your feet)

CLOSE YOUR EYES
(only with a friend
along, of course)

DRIFT
(head in the direction
the wind is blowing)

Fig. 1 –
GIANT TREES

Find a good, clear map of your surroundings. Scour the area
in search of one particular item that interests you.
Record instances of this item as you wander,
transforming your map into a specialized wayfinder.

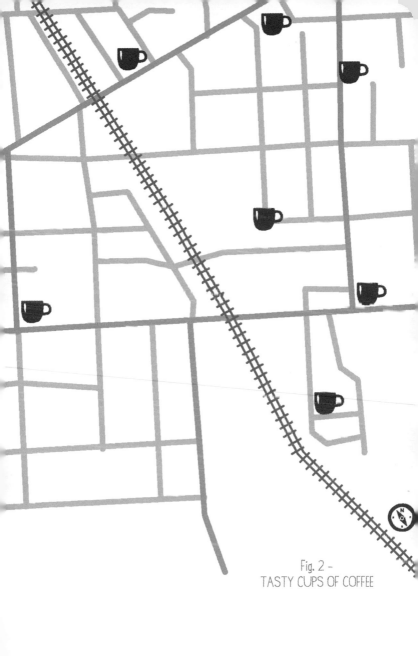

Fig. 2 –
TASTY CUPS OF COFFEE

SIGNAGE THAT TAKES ON NEW MEANING ONCE ON THE FRITZ

THIS HOTEL
IS VERY HOT

PARKING FOR
KINGS THIS WAY

Choose a particular theme for
the day and search for traces of it.

NEITHER OF THESE
HOURS OF OPERATION
MAKES MUCH SENSE

Shoot a first-person video
while trying to find a destination.
Alternatively, write a script of
your view while heading from
Point A to Point B.

Take note of the sky directly above you.
Observe where the next bird or airplane
you see is headed. Set out meandering
in the direction it's going.

Set out on foot. At each street corner,
flip a coin to see which direction you should go next.
If it's heads, turn right. If it's tails, head to your left.

While you are out and about, think about handy additions to the usual signage found on your city streets. Design a new set of signs that would better suit the way you like to explore.

SIT
relax
&observe
what is
buzzing
around
you

$$$ MAR. 1 to 31 ALL INCL. 39649

SOME NICE PLACES TO SIT

CONCRETE BARRIER POSTS
(sit on one and put your feet on another)

BENCH
(thank the name on the plaque)

BUS STOP
(nice when it's raining)

MUNICIPAL PLANTER
(don't squish the flowers)

GRASSY PLOT
(maybe at a park or
outside the library)

STOOP
(if you are lucky enough to have one
or a friend's to borrow)

FOUNTAIN LEDGE
(you won't get wet)

TRUNK OF YOUR CAR
(rest your feet on the bumper)

Request a window seat at a café or restaurant.
Take time to sit still and revel in the importance of staring.
Sketch the minutiae going on around you.

- ☐ View from the window
- ☐ Types of dogs walking by
- ☐ Bumper stickers adorning cars on the street
- ☐ Items on your table

Keep your eyes peeled for city details that can be
recorded in this notebook as urban fossils.

STREET REPAIR HIEROGLYPHICS

PROPOSED
EXCAVATION

COMMUNICATION
CABLES

TEMPORARY
SURVEY

GASEOUS
MATERIALS

SEWERS &
DRAINS

RECLAIMED
WATER

ELECTRIC &
LIGHTING

POTABLE
WATER

Ⓣ TELEPHONE MANHOLE

Ⓖ GAS MANHOLE

Ⓔ ELECTRIC MANHOLE

R⊗ LOW-PRESSURE
HYDRANT TO RELOCATE

A⊗ LOW-PRESSURE
HYDRANT TO ADJUST

⊗ HIGH-PRESSURE
HYDRANT

Ⓛ METAL STREETLIGHT

Ⓤ WOODEN UTILITY POLE
WITH STREETLIGHT

Ⓤ WOODEN UTILITY POLE

Ⓢ SEWER

TREE TO STAY

TREE TO BE REMOVED

Stop what you are doing and look in the direction of the most prominent sound you hear. Describe the noise in one word and record where the sound is emanating from.

KABLAM
MEOW
BEEP
HICCUP
SQUISH
KERPLUNK
TICKTOCK
SHUFFLE
BOING
KNOCK
SLURP
TOOT
SWOOSH
FIZZ
TWEET
RUSTLE
SIZZLE
VROOM
WHACK
UNTZ...UNTZ...UNTZ...

Keep a record of various joyful behaviors that you see while out and about.

ADULTS HOLDING HANDS

WHEN:
WHERE:
NOTE:

PERSON SINGING IN A CAR

WHEN:
WHERE:
NOTE:

STRANGER SAYING HELLO TO YOU

WHEN:
WHERE:
NOTE:

PERSON WEARING RED SHOES

HAHA HA HAAA HA HA HA HA
HA HA HA HA SNIFF HA HAAA
HA HA HAAA HA HA HAHA HA
HA HAHA HA HAAA HA HAHA
HA SNORT HA HHA HAHA HA
HA HAHA HA HA HAAA HA HA

SOMEONE LAUGHING

WHEN:
WHERE:
NOTE:

WHEN:
WHERE:
NOTE:

PERSON EATING FOOD ON A STICK

ADULT WITH A SKIP IN THEIR STEP

WHEN:
WHERE:
NOTE:

WHEN:
WHERE:
NOTE:

Observe and record data on different neighborhoods.
Create a snapshot of what makes each area unique.

CRITERIA	NEIGHBORHOOD #1
NUMBER OF DOGS YOU SEE IN 1 HOUR (NONE IN SIGHT, HERE & THERE, DOG SHOW)	
AVERAGE SIZE OF DOG (TINY, MID SIZED, GIGANTOR)	
KIND OF PIZZA ESTABLISHMENT (JOINT, DIVE, NEW FANGLED)	
MOST VISIBLE ACCESSORY (STROLLER, TIGHT PANTS, BLING)	
WRITING SCROLLED INTO WET PAVEMENT? (A NAME, LOVE LETTERS, A DRAWING)	
DRIED-UP BUBBLE GUM ON THE SIDEWALK? (AVERAGE AMOUNT IN ONE BLOCK)	
EXPRESSION OF STRANGERS YOU PASS (SMILE, BLANK STARE, RAISED EYEBROW)	
TYPE OF NATURAL LIGHT (TREE-LINED STREET, NO SHADE IN SIGHT)	
AVERAGE COLOR OF BUILDINGS (BRIGHT, MUTED, JEWEL-TONED, PASTEL)	
PUBLIC PLACES TO SIT? (BENCH, GRASSY PLOT, PARK, LEDGE)	
NUMBER OF PEOPLE YOU SEE JOGGING BY (SOLO, GROUPS OF TWO, TEAMS)	
TYPE OF SHOPS (BOUTIQUE, STRIP MALL, UTILITARIAN)	

NEIGHBORHOOD #2	NEIGHBORHOOD #3	NEIGHBORHOOD #4

Find a spot to sit and gaze. Take stock of all the different
types of city street furniture within your view.

✓ LAMPPOSTS
✓ BUS STOPS
✓ FIRE HYDRANTS
✓ NEWSSTANDS
✓ MAILBOXES

COLLECT

gather
data &
keepsakes
along
the way

12
MONTH PASS
ALL INCL.
51645

THINGS TO FIND IN MACHINES

Try to find all of these colors during the course of your walk.
Record where you were when you found them and
which objects happened to be a perfect match.

Smudge this page with seemingly insignificant things you pass while walking in the neighborhood. Let this collection act as a snapshot of the little things you usually don't pay attention to.

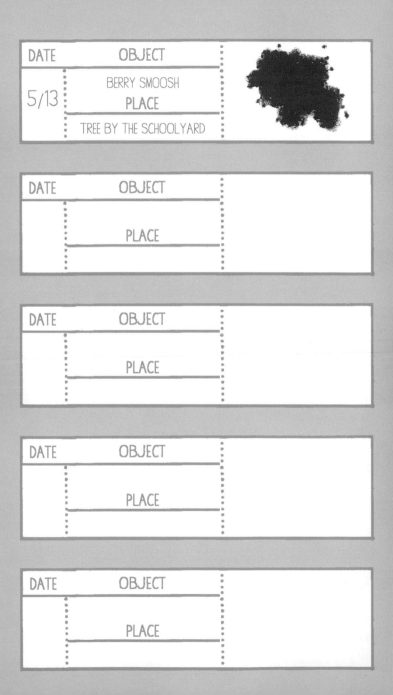

DATE	OBJECT
5/13	BERRY SMOOSH
	PLACE
	TREE BY THE SCHOOLYARD

DATE	OBJECT
	PLACE

DATE	OBJECT
	PLACE

DATE	OBJECT
	PLACE

DATE	OBJECT
	PLACE

DATE	OBJECT	
	PLACE	

DATE	OBJECT	
	PLACE	

DATE	OBJECT	
	PLACE	

DATE	OBJECT	
	PLACE	

DATE	OBJECT	
	PLACE	

DATE	OBJECT	
	PLACE	

As you meander throughout your day, take note of the smells wafting in your path. Describe the odors you detect and what you think is causing them. Do they trigger any memories?

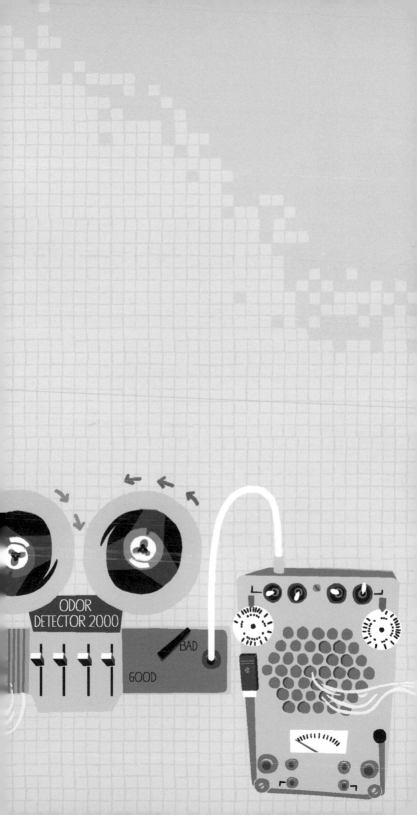

Search for a spot you can stay put for about an hour. Transcribe snippets of conversations happening around you. If you can't hear clearly, make up the dramatic, silly, or mundane interactions you imagine are taking place.

There is signage all around you.
Sketch or photograph the alphabet using various
typographic specimens you encounter during your day.

Draw or collect every weed you walk by in one block. If the area has been painstakingly pruned and there are no weeds in sight, take stock of the trees on the block by recording the leaves.

DANDELION
YELLOW
IS THE BEST
YELLOW

EAT

fill your belly & quench your thirst

AUG 1 to 31 ALL INCL.

.3174.

MONTH PASS

VARIOUS INTERNATIONAL SODAS

BRAZIL
(apple-ish)

PUERTO RICO
(like drinking wheat toast)

ENGLAND
(black currant)

INDIA
(bitter cola)

TAIWAN
(muted apple)

EL SALVADOR
(like an orange Creamsicle)

EGYPT
(malted apple
with a pull-tab top)

PAKISTAN
(lime cream soda)

MEXICO
(named after the
football team)

KOREA
(like drinking
Big Red gum)

CUBA
(pineapple fizz)

IRELAND
(sour with
fruit bits)

TRINIDAD
(no need to chew)

JAPAN
(salty citrus
ion supply drink)

GHANA
(sweet maple flavor)

ITALY
(bitter herbal Amaro)

When eating out, order the weirdest thing on the menu.
The unusual items are often the tastiest. At the very
least, you will have a good story to tell others.

ITEM TRIED: ☐ YUM
☐ YUCK

ITEM TRIED: ☐ YUM
☐ YUCK

ITEM TRIED: ☐ YUM
☐ YUCK

ITEM TRIED: ☐ YUM
☐ YUCK

ITEM TRIED: ☐ YUM
☐ YUCK

ITEM TRIED: ☐ YUM
☐ YUCK

ITEM TRIED: ☐ YUM
☐ YUCK

ITEM TRIED: ☐ YUM
☐ YUCK

ITEM TRIED: ☐ YUM
☐ YUCK

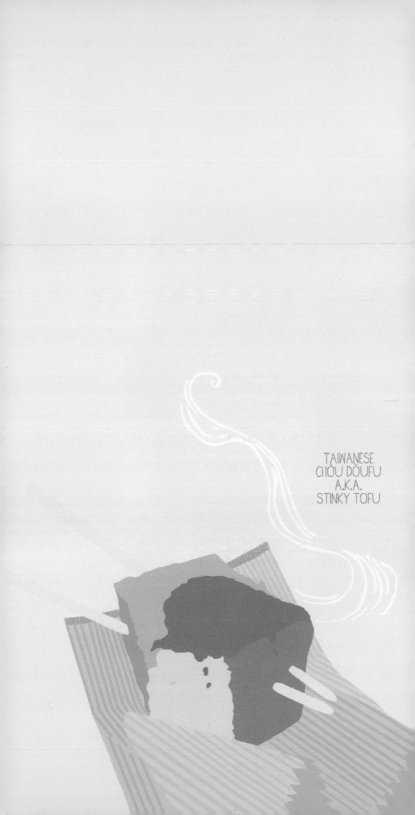

TAIWANESE
CHÒU DÒUFU
A.K.A.
STINKY TOFU

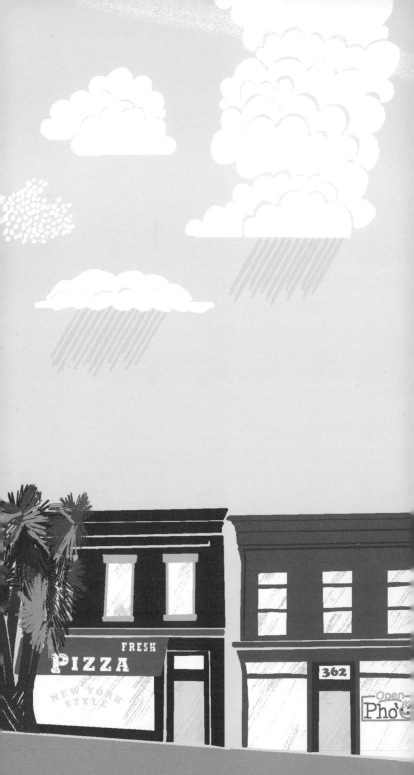

Pick a street in your city that
you have yet to explore thoroughly.
Starting at one end of the block,
eat at every restaurant on the street
in order. Each time you find yourself
trying to decide where to eat, pick up
where you left off until you reach the end.

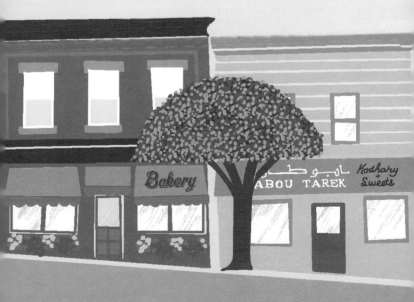

Go on the hunt for various international desserts in your
own city. If you can't find all of these, list what new and
unusual items you did try out along your journeys.

American	☐ sprinkle donuts
Argentine	☐ dulce de leche
Australian	☐ lamington (cake-cube rolled in coconut)
Canadian	☐ Nanaimo bars
Chinese	☐ jin deui (sesame seed rice balls)
Cuban	☐ empanadas de guayaba (guava inside)
Danish	☐ kringle or flodeboller
Dutch	☐ stroopwafel
Eastern European	☐ babka
English	☐ banoffee pie
Filipino	☐ ube layer cake (made with purple yam)
French	☐ macaron (not the coconut kind...)
Indian	☐ jalebi
Indonesian	☐ pandan chiffon cake (it's chartreuse!)
Irish	☐ porter cake
Italian	☐ torta della nocciola (hazelnuts are the best!)
Japanese	☐ daifuku (find one with a strawberry inside)
Korean	☐ baesook (poached pears & peppercorns)
Malaysian	☐ kuih lapis (most colorful dessert of all time)
Mediterranean	☐ baklava
Mexican	☐ paleta (fresh fruit ice pop)
New Orleanian	☐ beignets
Peruvian	☐ picarones
Russian	☐ tea cakes
Scottish	☐ petticoat tails shortbread
South African	☐ malva pudding
Swedish	☐ princess cake (traditionally green)
Syrian	☐ ma'amoul (date pastries)
Taiwanese	☐ boba (flavored milk tea & tapioca)
Thai	☐ mango with sticky rice
Turkish	☐ Turkish delight

JIN DEUI
(Chinese)

MACARON
(French)

UBE LAYER CAKE
(Filipino)

SPRINKLE DONUT
(American)

PRINCESS CAKE
(Swedish)

PALETA
(Mexican)

DAIFUKU
(Japanese)

STROOPWAFEL
(Dutch)

JALEBI
(Indian)

KUIH LAPIS
(Malaysian)

DATE LOCATION MEAL

.......

.......

.......

.......

.......

While eating at a restaurant,
try to decode the spices
used in your meal.

PICES

···
···
···
···
···
···
···
···
···
···

Write the name of what you are drinking right
now using the beverage's liquid as ink.

a big iced tea

BOX WINE

BLUE SLUSHY

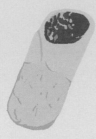

BURRITO

FRESH SHRIMP
ROLL

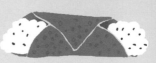

CANNOLI

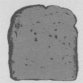

TOAST

RAVIOLI

12,60

JAPANESE
SQUARE
WATERMELON

PIZZA

HAMANTASCHEN

SPANAKOPITA

SPUN SUGAR

SPAGHETTI

FRIES

Embark on a day of eating uniformly shaped food.

☐ TUBE

...

...

...

...

...

☐ SQUARE

...

...

...

...

...

☐ POINTY

...

...

...

...

...

☐ TANGLED

...

...

...

...

...

MEET

mingle with whoever crosses your path

DEC
1 to 31

Monthly PASS

14822B

ALL INCL

$

APPROACHABILITY GAUGE

ARMS AKIMBO
(confident)

FURROWED BROW
(distressed, concerned,
or in disagreement)

HEAD IN BOOK
(probably doesn't want
to be bothered)

EXCESSIVE JIGGLING
(nervous or uncomfortable)

LEGS CROSSED
(comfortable)

HAIR TWIRLING
(bored or preoccupied)

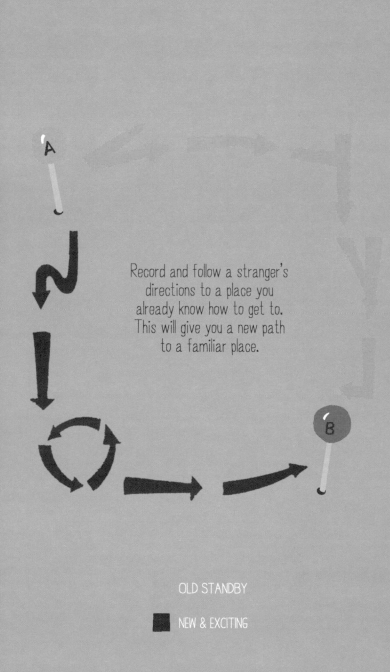

Record and follow a stranger's directions to a place you already know how to get to. This will give you a new path to a familiar place.

OLD STANDBY

NEW & EXCITING

Ask for restaurant recommendations
from the server or staff at a
place you regularly eat at.

PLACE TO CHECK OUT:

WHO SUGGESTED IT:

- []
- []
- []
- []
- []
- []
- []
- []
- []
- []
- []
- []
- []
- []
- []
- []
- []
- []
- []
- []

Get an assignment from the clerk
at a local convenience store.
Ask him or her to tell you where
your next stop should be in the
neighborhood and to draw you
a map as a guide.

NAME: .

WHERE WE MET: .

ASSIGNMENT: .

. .

. .

. .

. .

. .

. .

Make an encouraging card for a public transporation employee.
Compose what you want to say below.

☐ BUS DRIVER

☐ TOLLBOOTH OPERATOR

☐ CROSSING GUARD

☐ SUBWAY CUSTODIAN

LITTLE CARD
HUGE
thanks

THE SUN IS
shining
THE DAY IS
long
AND IT'S ALMOST
quittin' time

YOU TAKE ME
TO WORK IN THE
MORNING;
NOW TAKE TIME FOR
YOURSELF

Be a surveyor. Record the answers to questions you ask each stranger that you encounter along your way.

STRANGER #1

WHAT IS YOUR SIMPLE PLEASURE?	
WHAT TIME DO YOU AWAKE ON WEEKDAYS?	
WHAT TIME DO YOU AWAKE ON WEEKENDS?	
WHAT IS YOUR FAVORITE TIME OF DAY?	
BEST THING TO DO ON SUNDAY MORNING?	
WHAT DO YOU SPREAD ON TOAST?	
WHAT'S YOUR FAVORITE QUIET SPOT?	
WHAT'S YOUR FAVORITE BUSTLING PLACE?	
DO YOU WEAR SOFT PANTS OUTSIDE?	
WHERE DO YOU RENDEZVOUS WITH FRIENDS?	
HOW DO YOU GET AROUND TOWN?	
HOW MANY...	
WHAT IS...	

10-SECOND MICROPORTRAITS

STRANGER #2 STRANGER #3 STRANGER #4

Schedule public office hours.
Send your friends a schedule of your
proposed whereabouts for the day and
then have them schedule meetings with
you while you are out and about.

THINGS TO DO:

☑ WALK THROUGH THE NEIGHBORHOOD

☐ STOP BY LAUNDROMAT

☐

☐

☐

☐

☐

☐

☐

☐

☐

☐

☐

PEOPLE TO INVITE:

☐

☐

☐

☐

☐

☐

☐

☐

☐

☐

☐

☐

☐

WHEREABOUTS:

7 a.m. ...

8 a.m. ...

9 a.m. ...

10 a.m. ...

11 a.m. ...

12 p.m. ...

1 p.m. ...

2 p.m. ...

3 p.m. ...

4 p.m. ...

5 p.m. ...

6 p.m. ...

7 p.m. ...

8 p.m. ...

9 p.m. ...

10 p.m. ...

11 p.m. ...

12 a.m. ...

1 a.m. ...

SHARE
record your advice column

MY FAVORITE SPOT TO WATCH THE SUNSET:

THE MOST UNDERRATED CAFE:

THE COZIEST PLACE I GO TO UNWIND:

THE SMELLIEST STREET:

THE GREATEST SPOT TO HEAR LOCAL MUSIC:

MY ALL-TIME FAVORITE URBAN HIKE:

THE MOST CHAOTIC AREA OF TOWN:

THE VERY BEST SUNDAY MORNING BREAKFAST SPOT:

RESTAURANT REVIEWS

Place I Went:

☐ dive ☐ charming ☐ fancy-pants

Tried The:

... ☐ yum ☐ yuck

... ☐ yum ☐ yuck

... ☐ yum ☐ yuck

The Secret Ingredient Is:

...

Don't Miss The:

...

General Thoughts:

...

...

...

Place I Went:

☐ dive ☐ charming ☐ fancy-pants

Tried The:

... ☐ yum ☐ yuck

... ☐ yum ☐ yuck

... ☐ yum ☐ yuck

The Secret Ingredient Is:

...

Don't Miss The:

...

General Thoughts:

...

...

...

Place I Went:

☐ dive ☐ charming ☐ fancy-pants

Tried The: .. ☐ yum ☐ yuck

.. ☐ yum ☐ yuck

.. ☐ yum ☐ yuck

The Secret
Ingredient Is: ..

Don't Miss The: ..

General
Thoughts: ..

..

..

Place I Went:

☐ dive ☐ charming ☐ fancy-pants

Tried The: .. ☐ yum ☐ yuck

.. ☐ yum ☐ yuck

.. ☐ yum ☐ yuck

The Secret
Ingredient Is: ..

Don't Miss The: ..

General
Thoughts: ..

..

..

Place I Went:

☐ dive ☐ charming ☐ fancy-pants

Tried The:

.. ☐ yum ☐ yuck

.. ☐ yum ☐ yuck

.. ☐ yum ☐ yuck

The Secret Ingredient Is:

..

Don't Miss The:

..

General Thoughts:

..

..

..

Place I Went:

☐ dive ☐ charming ☐ fancy-pants

Tried The:

.. ☐ yum ☐ yuck

.. ☐ yum ☐ yuck

.. ☐ yum ☐ yuck

The Secret Ingredient Is:

..

Don't Miss The:

..

General Thoughts:

..

..

..

Place I Went:

☐ dive ☐ charming ☐ fancy-pants

Tried The: ☐ yum ☐ yuck

.. ☐ yum ☐ yuck

.. ☐ yum ☐ yuck

The Secret
Ingredient Is:
...

Don't Miss The:
...

General
Thoughts:
...

...

...

Place I Went:

☐ dive ☐ charming ☐ fancy-pants

Tried The: ☐ yum ☐ yuck

.. ☐ yum ☐ yuck

.. ☐ yum ☐ yuck

The Secret
Ingredient Is:
...

Don't Miss The:
...

General
Thoughts:
...

...

...

94

Place I Went:

☐ dive ☐ charming ☐ fancy-pants

Tried The: ☐ yum ☐ yuck

............................ ☐ yum ☐ yuck

............................ ☐ yum ☐ yuck

The Secret
Ingredient Is: ..

Don't Miss The: ..

General
Thoughts: ..

..

..

Place I Went:

☐ dive ☐ charming ☐ fancy-pants

Tried The: ☐ yum ☐ yuck

............................ ☐ yum ☐ yuck

............................ ☐ yum ☐ yuck

The Secret
Ingredient Is: ..

Don't Miss The: ..

General
Thoughts: ..

..

..

Place I Went:

☐ dive ☐ charming ☐ fancy-pants

Tried The:

☐ yum ☐ yuck

☐ yum ☐ yuck

☐ yum ☐ yuck

The Secret
Ingredient Is:

Don't Miss The:

General
Thoughts:

Place I Went:

☐ dive ☐ charming ☐ fancy-pants

Tried The:

☐ yum ☐ yuck

☐ yum ☐ yuck

☐ yum ☐ yuck

The Secret
Ingredient Is:

Don't Miss The:

General
Thoughts:

Place I Went:

☐ dive ☐ charming ☐ fancy-pants

Tried The: .. ☐ yum ☐ yuck

.. ☐ yum ☐ yuck

.. ☐ yum ☐ yuck

The Secret
Ingredient Is: ..

Don't Miss The: ..

General
Thoughts: ..

..

..

Place I Went:

☐ dive ☐ charming ☐ fancy-pants

Tried The: .. ☐ yum ☐ yuck

.. ☐ yum ☐ yuck

.. ☐ yum ☐ yuck

The Secret
Ingredient Is: ..

Don't Miss The: ..

General
Thoughts: ..

..

..

NEIGHBORHOOD FAVORITES

Neighborhood:

Things To Observe:

Adventures To Have:

Places To Eat:

Places To Mingle:

Shops To Visit:

Streets To Stroll:

People To Talk To:

Neighborhood:

Things To Observe:

Adventures To Have:

Places To Eat:

Places To Mingle:

Shops To Visit:

Streets To Stroll:

People To Talk To:

Neighborhood:

Things To Observe:

Adventures To Have:

Places To Eat:

Places To Mingle:

Shops To Visit:

Streets To Stroll:

People To Talk To:

Neighborhood:

Things To Observe:

Adventures To Have:

Places To Eat:

Places To Mingle:

Shops To Visit:

Streets To Stroll:

People To Talk To:

Neighborhood:

Things To Observe:

Adventures To Have:

Places To Eat:

Places To Mingle:

Shops To Visit:

Streets To Stroll:

People To Talk To:

Neighborhood:

Things To Observe:

Adventures To Have:

Places To Eat:

Places To Mingle:

Shops To Visit:

Streets To Stroll:

People To Talk To:

Neighborhood:

Things To Observe:

Adventures To Have:

Places To Eat:

Places To Mingle:

Shops To Visit:

Streets To Stroll:

People To Talk To:

Neighborhood:

Things To Observe:

Adventures To Have:

Places To Eat:

Places To Mingle:

Shops To Visit:

Streets To Stroll:

People To Talk To:

Neighborhood:

Things To Observe:

Adventures To Have:

Places To Eat:

Places To Mingle:

Shops To Visit:

Streets To Stroll:

People To Talk To:

Neighborhood:

Things To Observe:

Adventures To Have:

Places To Eat:

Places To Mingle:

Shops To Visit:

Streets To Stroll:

People To Talk To:

THE VERY BEST ...

IN THE CITY IS ..

THE VERY BEST ...

IN THE CITY IS ..

THE VERY BEST ...

IN THE CITY IS ..

THE VERY BEST ...

IN THE CITY IS ..

THE VERY BEST ...

IN THE CITY IS ..

THE VERY BEST ...

IN THE CITY IS ..

THE VERY BEST ...

IN THE CITY IS ..

THE VERY BEST ...

IN THE CITY IS ..

THE VERY BEST

plus...

Create an advertisement for a place
you love in your neighborhood.

IF SO & SO VISITS	THEY SHOULD CHECK OUT ...

SO & SO TOLD ME I MUST SEE THE . . .

......................

......................

......................

......................

......................

......................

......................

......................

......................

......................

......................

SO & SO TOLD ME TO AVOID THE . . .

......................

......................

......................

......................

......................

......................

......................

......................

......................

......................

NOTES
observations, stories, & encounters collected miscellany